Daniela
Keiser

London —
Being in the Library

PARK BOOKS

The publication of this book was supported by

Ernst und Olga Gubler-Hablützel Foundation
Graphische Sammlung ETH Zürich
Stiftung Erna und Curt Burgauer
LANDIS&GYR STIFTUNG

 KULTUR RAUM.SH
Kanton Schaffhausen Kulturförderung

 Stadt Zürich Kultur

The artist's special thanks go to David Adjaye and Philip Ursprung, Luisa Alves, Zoe Simpson, Annie Derbyshire Gilli und Diego Stampa, Nadine Olonetzky, Lisa Schons, Louise Stein, Thomas Kramer, Valeria Bonin, Diego Bontognali, Arno Hassler. And to Sara, Isis, Amy, Elen, Achmed, Mike, Rick, Mark, Selina.

In addition, the artist would like to thank all the others who have contributed in any way to the success of this project, and theprintspace, Hackney, London, and DZA Druckerei zu Altenburg, Thüringen.

This book is based on the 153-part photo installation *Library—Idea Store, 321 Whitechapel Rd, Shadwell, London E1 1BU* (2017/2018, Courtesy STAMPA Gallery, Basel).

The book's cover is based on the two-part edition *Idea-Store, Whitechapel Road* (2020), which was realized in collaboration with Arno Hassler in the technique of heliogravure and chine-collé.

Concept and Editing: Daniela Keiser
Photos: Daniela Keiser
Text: Philip Ursprung, David Adjaye
Copy Editing: Lisa Schons
Proofreading: Louise Stein
Design: Bonbon, Zurich
Typeface: Gill Sans
Paper: GardaGloss Art, Holmen Trend, Munken Polar
Lithographs, Printing, and Binding: DZA Druckerei zu Altenburg, Thüringen

© 2021 Park Books AG, Zurich
© for the images: Daniela Keiser
© for the text: Philip Usprung, David Adjaye

Park Books AG
Niederdorfstrasse 54
8001 Zurich
Switzerland

www.park-books.com

ISBN 978-3-03860-234-7

Park Books is being supported by the Federal Office of Culture with a general subsidy for the years 2021–2024.

Let's learn together

A Conversation between Sir David Adjaye and Philip Ursprung

London, 20 June 2019

During a residency in London in winter 2017/18 Daniela Keiser discovered the Idea Store Whitechapel. She was immediately drawn in by the atmosphere, the spaces and the people she encountered, so she decided to visit the Idea Store regularly and take pictures with her phone. Not of the people though—because she did not want to be a voyeur—and not of the building either, but instead 'from' the building. She found a brochure entitled 'Let's Learn Together' and took a course on studio portrait photography. During this course, her co-student Annie Derbyshire mentioned to her that the building had been built by a famous architect. Therefore, she asked me to have a conversation with you so that your voice would find a place in her book. The Idea Store is one of your earliest projects, having opened in 2004. Can you say something about the planning for it?

Philip Ursprung

I listened to the people. They felt far removed from the epicentre of the city, almost like in a village. Although since then Whitechapel has totally changed. One of my goals was to create a pathway through the building which acts as a device for the community to understand its context from a different vantage point. In developing the project, I became fascinated with the idea of a journey that would collect people at the base of the building, wind them through a series of programmes and educational facilities and always frame particular vantage points. That was a way to represent their context, to show how privileged their community was in terms of its relationship to the centre of the city. Even though it was poor, it had this extraordinary relationship. At that time there was no public architecture that offered such a vantage point.

Sir David Adjaye

Daniela discovered a special window in the façade and thought that the architect must have designed this window for her—as a huge camera, so to speak. From this window she photographed the street over the course of several weeks. It was the first time that she did not work with a real camera, but with a phone, a 'collective medium', as she puts it, because most people own one. She used a portrait format, because it corresponds to architecture and to the orientation of a book page. The Idea Store as such only sporadically appears in the guise of the reflection of the red floor or the green-blue façade in the glass.

Philip Ursprung

It is beautiful that Daniela was fascinated by this view. The Idea Store looks like a glass building, but it is actually an insulated building with glass panels. The culmination of the journey through the building is the moment when there is one clear window in the entire sequence which isn't hidden behind any insulated panels. I calculated this and put all the insulation somewhere else so that I could open up this panorama of the city. The view summarizes the idea of empowering the ordinary citizens within the context of their environment.

Sir David Adjaye

Daniela perceived the Idea Store as a place of dialogue. She saw many people there, some very poor, some even homeless. Apart from the people learning, there were others who seemed to be there simply because it was warm, because of the bathrooms or the free Wifi. Most of the time she sat in the cafeteria with a cup of tea, and people started to get used to her being there. She asked them questions about their daily life. Can you tell me more about the programme of this space?

Philip Ursprung

The Idea Store was deliberately not called a library. A library evokes ideas of academia and study. We wanted to create a space that every ordinary citizen feels comfortable to step into, a building almost like a piece of infrastructure for the community. The changing of the name was critical to that. It allowed people to feel that they could just walk in and use the bathroom, just sit around and look out the window. And that is fine, because in doing so a few times they might see a book, they might see someone on the computer, they might see a course that they find interesting. They might encounter something that is different from their daily routines. We were specifically thinking about adult education and lifelong learning. Many are intimidated by this. But learning is evoked through role-playing, seeing others doing it and thinking that one can be part of it as well. The building is an invitation, a device to create dialogue. It encourages visual and social dialogue—edification through education one could say.

Sir David Adjaye

Daniela was amazed by the sounds and the atmospheres in the building. She found it busy yet calm. This is another reason why she asked me to meet you. She wanted to know if the architect was calm himself, and if he was interested in the concept of sound. How do you deal with sound?

Philip Ursprung

I am obsessed with sound. I have a brother who is an amazing musician and composer. From the beginning of my career, sound and resonance have been crucial elements in my projects. Resonance is important not only because of technical reasons, but also because of atmospheres. It is about creating atmospheres and spaces. For me, the acoustic effects come before the visual effects. The acoustic, atmospheric effect plays very directly with the subconscious. It affects the people even before they realize what is going on.

Sir David Adjaye

When Daniela found out that you designed a loud-speaker she was not surprised. How did you design these acoustic effects in the Idea Store?

Philip Ursprung

There are a lot of devices to absorb sound all over the space. Where I don't want that to happen, I bring the sounds back to life. For instance, in the staircases or in the cafeteria where it is much livelier. But in the teaching areas or among the bookstacks I went to a lot of effort to use absorbing materials, to dampen the noise. The bookstacks are arranged like semi-amphitheatres, like aedicular chambers. They are not linear like in university libraries. The reason for that was not because of aesthetics, but in order to create secondary, framed spaces that provide comfort and acoustic enclosure. If a library is for the public and not mainly for academia, the idea of going to some central reading area is not appropriate. If you have never been to a library, never studied at a university, like many people in that community, it is a strange thing to sit at a large table with lots of lights and many people. I tried to allow people to feel comfortable and to be open to learning. The shelves provide a sense of comfort, a sense of feeling that this is a place where one can relax and hopefully absorb.

Sir David Adjaye

Daniela spent a lot of time in the Idea Store. She went there every couple of days; she watched the construction site of the tube, witnessed the 'Ophelia' storm. Her images do not depict the Idea Store, but on almost every photograph she shows the neighbouring building—an old, silent house that stands in contrast to the busy street with its market. Can you say something about that building?

Philip Ursprung

For me that was a very important and beautiful view. It tells us something about prosperity during the Victorian age. This corner architecture is one of the last fragments of the Victorian period, when London prospered and the area stopped being just a slum outside of the city. It is kind of an interesting remnant, since the city is changing so rapidly today. Eventually it might go. It is in a conservation area but it is not listed. There is also an opposite view from another window to the pediment of the old Truman Brewery. I deliberately designed the windows for these two views: one framing the Victorian world and the skyline of the modern city; and the second one framing the Victorian pediment. These are ways of understanding the history of the East End of the time around 1850. One is about the commercial and residential world, the other about production, the engine of the economy. The Idea Store is also a sort or registrar, trying to give you a sense of the different layers of history.

Sir David Adjaye

Daniela Keiser, born in Neuhausen, CH, in 1963, is a Swiss concept and installation artist. In her work, she deals with visual studies, photography, collage and language/translation. In her work the spatial and social environment and urban space are playing an important role (environment). Daniela Keiser lives and works in Zurich. From 1988 to 1989 she attended the preliminary course at the Zurich University of the Arts and from 1988 to 1991 she studied free spatial design and sculpture at the University of Art and Design in Basel. Since 2008 she has been teaching at the Bern University of the Arts. Some of her works were created as part of various studio grants and longer stays abroad in Istanbul, Cairo and London, Berlin, Paris and New York. The interdisciplinary exchange across cultural boundaries is a central part of her work. In 2017 she was awarded the prestigious the Swiss Grand Prix Art (Prix Meret Oppenheim), and in 2019 the recognition prize of the Foundation for Graphic Art in Switzerland, ETH Zurich.

danielakeiser.ch

Philip Ursprung, born in Baltimore, USA, in 1963, is an art and architecture historian. He studied in Geneva, Vienna and Berlin. In 1993 he received his doctorate from FU Berlin. He taught at the University of Zurich, the Universität der Künste Berlin, Columbia University New York, and the Barcelona Institute of Architecture and Cornell University and was researcher at the Future Cities Laboratory of Singapore ETH Center in Singapore. Since 2011 he has been Professor of the History of Art and Architecture at the Department of Architecture of ETH Zurich. In 2017 he was awarded the Prix Meret Oppenheim. Publications include *Herzog & de Meuron: Natural History* (editor, 2002) and *Die Kunst der Gegenwart* (2010), *Allan Kaprow, Robert Smithson, and the Limits to Art* (2013), and *Der Wert der Oberfläche* (2017).

Sir David Adjaye, born in Dar es Salaam, Tanzania, in 1966, is a British architect. He studied i.a. at the London South Bank University and at the Royal College of Art, then worked with, among others, David Chipperfield and Eduardo Souta de Moura. From 1994 to 2000 he ran an architecture office with William Russell. Today he has his own offices in Hoxton, Berlin and New York. From 2001 he built Idea Stores for the city libraries in London's East End, in 2002 he designed the Nobel Peace Center in Oslo, and in 2008 he won the competition for the National Museum of African American History and Culture at the Smithsonian Institution in Washington D.C. David Adjaye teaches at the Architectural Association (AA) in London and was raised to the nobility by Queen Elisabeth in 2017.

adjaye.com

Biographies